CLASSIC IMAGES OF

CANADA'S FIRST NATIONS

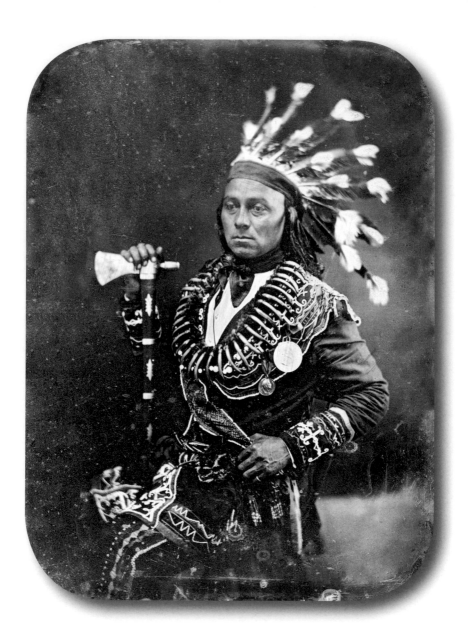

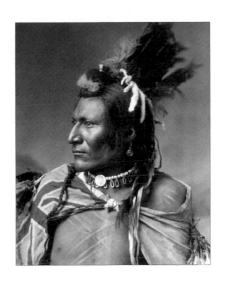

CLASSIC IMAGES OF
CANADA'S FIRST NATIONS
1850—1920

EDWARD CAVELL

VICTORIA · VANCOUVER · CALGARY

Heritage House Publishing Company Ltd.
heritagehouse.ca

LIBRARY AND ARCHIVES CANADA CATALOGUING IN PUBLICATION

Cavell, Edward, 1948–
 Classic Images of Canada's First Nations: 1850–1920 / Edward Cavell.

ISBN 978-1-894974-64-6

 1. Indians of North America—Canada—History—Pictorial works. I. Title.
E78.C2C42 2009 971.004'9700222 C2009-900091-1

A portion of this book previously published in 2007 under title
Classic Images of Canadian First Nations

Edited by Lara Kordic
Proofread by Lesley Reynolds
Cover design by Jacqui Thomas
Interior design by Frances Hunter

Front cover and **page 3:** Studio portrait of Old Brass, who was Siksika (Blackfoot), made in Calgary, Alberta, *circa* 1887, by Alexander J. Ross (Glenbow Archives, PA-10-10).
Back cover: Stoney Nakoda mother and child (Whyte Museum of the Canadian Rockies, V48-1582).
Page 2: Maun-gua-daus (Great Hero), also known as George Henry, an Ojibwa chief from Port Credit, Ontario, *circa* 1847. In 1845 he formed a First Nations dance group and toured Europe with American artist George Catlin. This rare image, one of the first photographs of a Native Canadian, is a daguerreotype. It may have been taken in England while Maun-gua-daus was on tour; the photographer is unknown (Library and Archives Canada, PA-125840).

Heritage House acknowledges the financial support for its publishing program from the Government of Canada through the Canada Book Fund (CBF), Canada Council for the Arts, and the province of British Columbia through the British Columbia Arts Council and the Book Publishing Tax Credit.

 Canadian Heritage Patrimoine canadien The Canada Council | Le Conseil des Arts for the Arts | du Canada BRITISH COLUMBIA ARTS COUNCIL

18 17 16 15 3 4 5 6

Printed in Canada

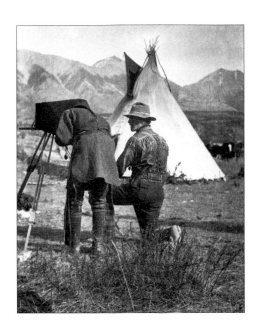

INTRODUCTION

Photographs have an amazing power to speak to us. Sometimes it's the skill of a talented photographer that captures the subject's soul. Sometimes the subjects are so striking that they overcome all the technical limitations of the medium to become etched indelibly into our history. Occasionally, serendipity seizes the moment; an expression, a gesture or a quirk of lighting gives voice to an image. Sometimes the photograph just shouts its story.

As the images in this collection speak to us, we have to keep in mind what they are *not* saying. At first a painfully slow process, the decade-old medium of photography had advanced by the 1850s to the point that it could capture many aspects of daily life in our emerging nation. However, the cumbersome equipment, long exposure times and convoluted nature of the process ensured that many things went unrecorded. Few photographs were taken indoors, and it was not really possible to record laughter, casual gestures and motion until the technology significantly improved toward the end of the 19th century.

Above all, the fundamental bias of the dominant society and the photographers greatly affected what we see today. Victorian Canada was not a particularly sensitive, accepting or expansive society. First Nations were considered lost cultures, at best, doomed to vanish completely in the relentless march of civilization. Fortunately, the Victorians were wrong.

Along with an attitude of respect for the essential role of First Nations in our history, we recognize that terminology has evolved considerably within both First Nations and Canadian society as a whole. In this book, we have tried wherever possible to identify the subjects of the photos with the traditional terms preferred by the First Nations. To simplify things, we have used modern place names, referring to current cities and provinces rather than the territories or colonies of the time. We have also identified as many of the photographers as possible to give them their often-overlooked due. A few comments have been added to help viewers appreciate the joys, foibles and limitations of the photographic process.

This publication is not a definitive survey of Canada's First Nations; hundreds of groups across the country could not be represented here. This incidental history simply gives small glimpses of the richness of the photographic material that has survived to lead us on a voyage of discovery.

Page 5
An unidentified Wesley Band member (Stoney Nakoda) with Elliott Barnes (1866–1938), Kootenay Plains, Alberta, 1907. The world would have appeared upside down on the camera's ground-glass screen. Photographed by guide Reginald Holmes.

Opposite
An unidentified leader of the Six Nations Iroquois Confederacy (Mohawk, Onondaga, Seneca, Cayuga, Oneida and Tuscarora) on the Grand River Reserve near Brantford, Ontario, *circa* 1850. The image is an ambrotype, one of the earliest photographic processes popular in the 1850s and 1860s, taken by an unknown photographer. These delicate, one-of-a-kind photographs on glass were typically presented in a gilt frame and mat held in an ornate gutta-percha (a natural latex) case.

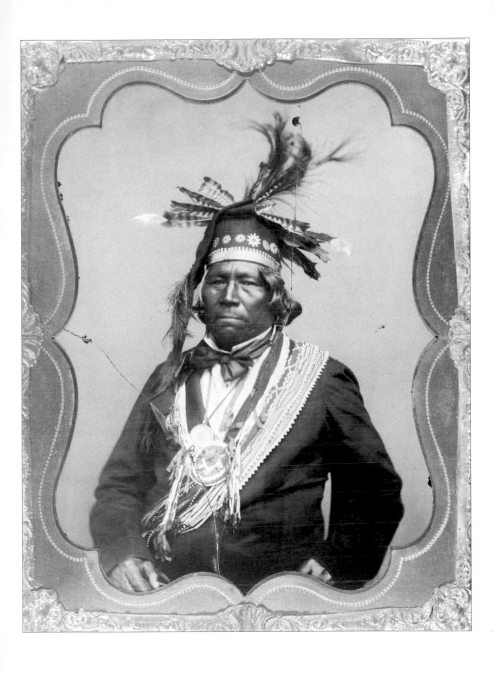

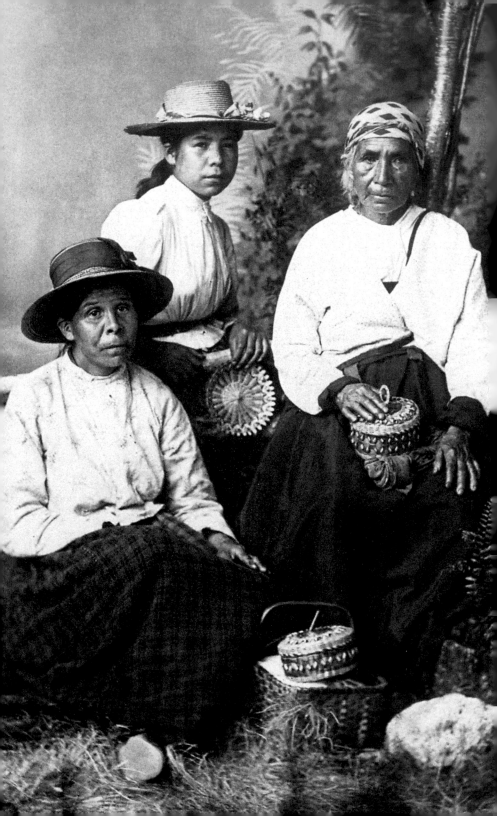

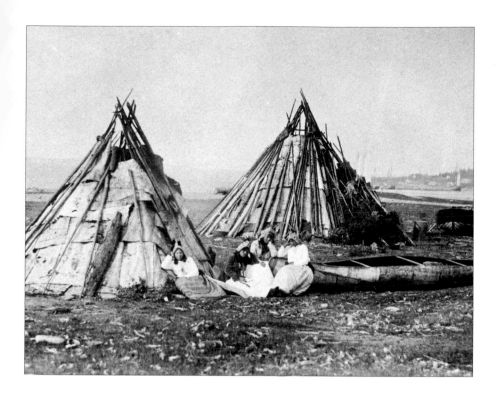

Opposite
Three Mi'kmaq women sit for a photo with wood-splint baskets, *circa* 1890. This image was captured in the Halifax studio of Montreal photographer William Notman (1826–1891). By the early 1880s, Notman had 20 branch studios, 7 in Canada and 13 in the United States.

Above
This 1857 Mi'kmaq camp, with its bark wigwams and canoes, was located near Sydney, Cape Breton Island, Nova Scotia. It was photographed by French naval officer Paul-Émile Miot (1827–1900).

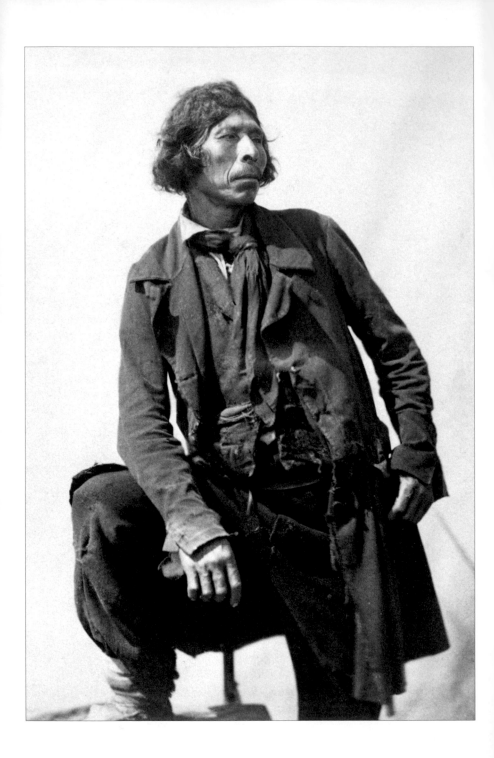

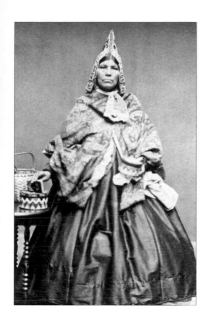

Opposite

Mi'kmaq traditional lands were concentrated in New Brunswick and Nova Scotia, but stretched from New England to Labrador. This photograph of a Mi'kmaq man was made in Newfoundland in 1859 by Paul-Émile Miot, using the slow and cumbersome wet-plate (collodion) process that required the photographer to travel with a complete darkroom. The light-sensitive emulsion was flowed onto a glass plate in the portable darkroom. Then the image was exposed and developed before the emulsion dried. A skilled operator could usually complete the process in about 15 minutes. This individual looks particularly relaxed considering that exposures were measured in seconds and subjects had to remain very still, generally resulting in a stiff, formal look.

Above

This Mi'kmaq woman stands for a photo with a wood-splint basket and a quillwork box. Taken *circa* 1868 by Joseph S. Rogers, active 1863–1874. The woman could be Mary Christianne Paul Morris, a well-known resident of Chocolate Lake, Nova Scotia, who posed for several artists. Decorative porcupine quills were used extensively by Native groups from the East Coast to the central plains. The quills were dyed, folded, twisted, wrapped, plaited and sewn.

Three Mi'kmaq women, on board a ship at St. George's Bay, Newfoundland, were photographed by Paul-Émile Miot in 1859. Miot's work is the earliest known use of photography in coastal Newfoundland. The west coast of Newfoundland was known as the French Shore.

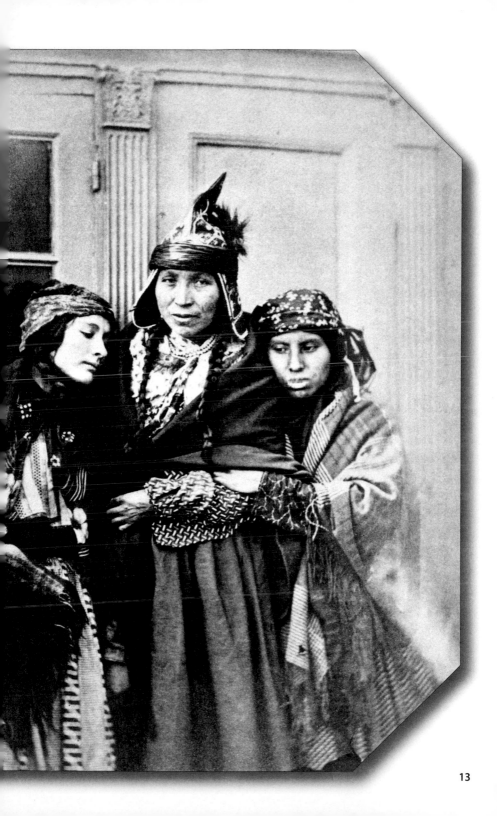

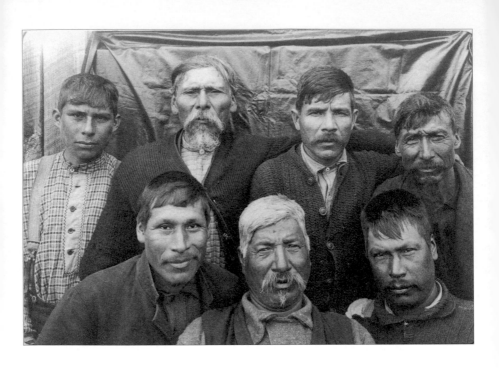

Mi'kmaq guides at Lake Jolly, Wright's Mills, Nova Scotia, on the occasion of a fishing expedition to Digby County, 1899. Front row (left to right): John Labrador, Simeon Pictou and Eli Pictou. Back row (left to right): Louis Peters, John Peters, John McEwen and John Louis. Attributed to J.A. Irvine.

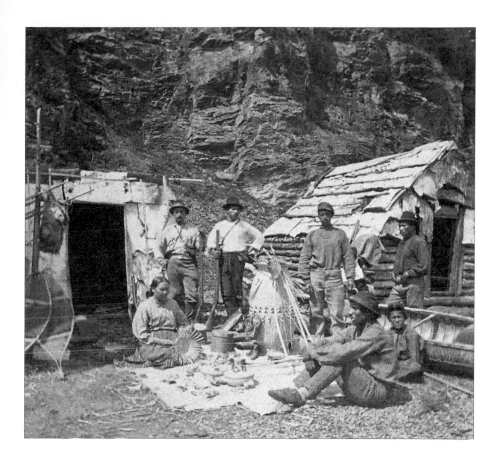

Half-stereo view of Montagnais basket maker and associates at Pointe-au-Pic (La Malbaie) on the north shore of the St. Lawrence River, Quebec, *circa* 1880, by Montreal photographer J.G. Parks, who was active between 1864 and 1894. Traditional crafts were pressed to the tourist trade. This settlement was close to the steamship landing for the exceptionally popular summer resort then known as Murray Bay.

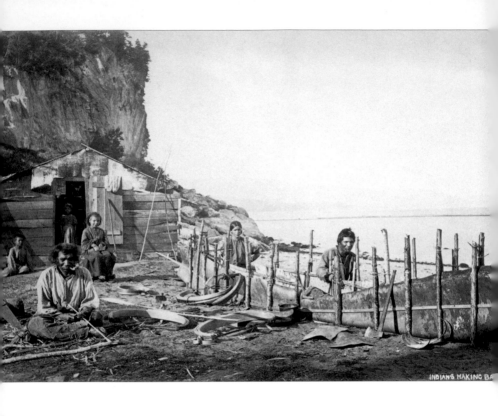

Montagnais making a bark canoe, Pointe-au-pic (La Malbaie
or Murray Bay), Quebec, *circa* 1863. Made from various barks,
most commonly birch, the canoe was steamed, soaked
and bent into place, taking about two weeks to build.
Photographed by Alexander Henderson (1831–1913), one
of Canada's most significant early photographers.

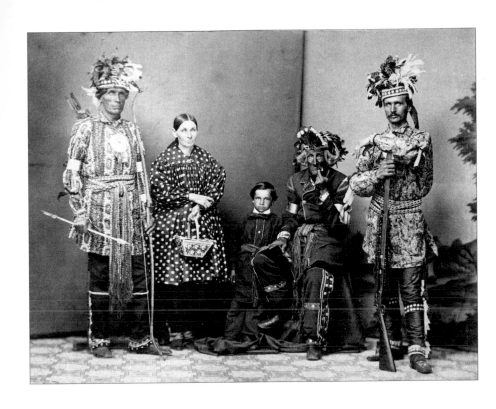

The Gros-Louis family, who were Huron-Wendat, came from Loretteville, just north of Quebec City. This photo was taken around 1880 by Jules-Ernest Livernois (1851–1933). The older gentleman (second from the right) is François Gros-Louis Sr., a colourful character and famed guide who appears in both William Notman's and Cornelius Krieghoff's images.

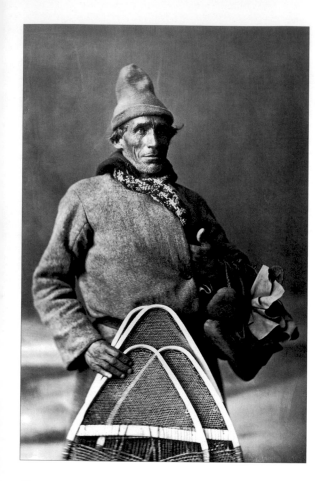

Above

François Gros-Louis of the Huron-Wendat Nation, photographed in 1866 by William Notman in Montreal, Quebec. His father and son (the young boy in the photo on page 17), both named François, were also often used as models in Notman's work.

Opposite

Huron-Wendat chief Philippe Vincent Teonthaostha poses for this photograph in Quebec City, *circa* 1880. In the mid-17th century, the Huron were dispersed from their traditional lands in eastern Ontario by the Iroquois Confederacy. Most moved south to the United States; a small group moved to Loretteville, near Quebec City. He was photographed by Jules-Ernest Livernois.

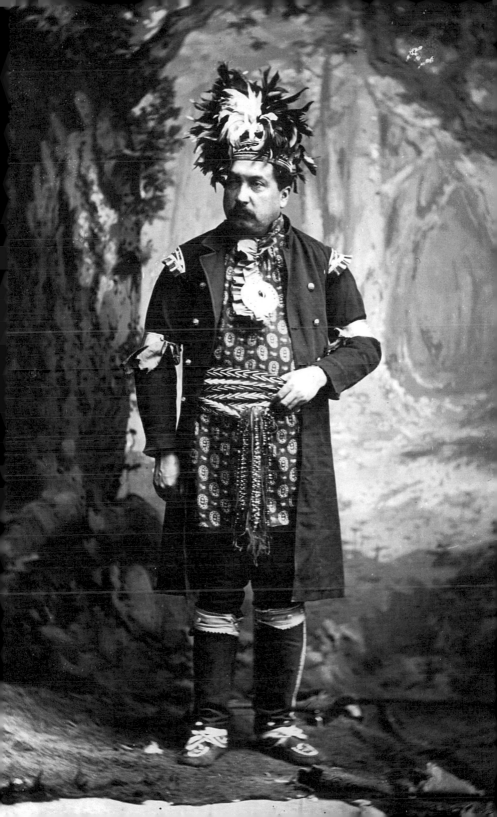

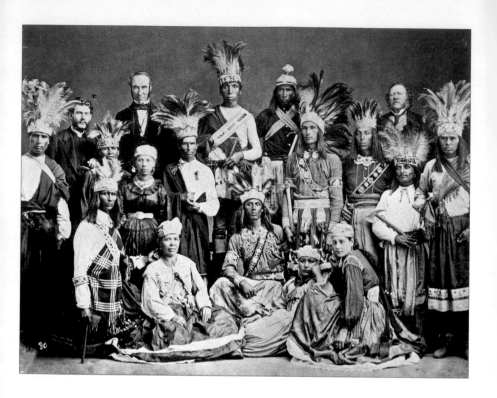

Above

This group from Kahnawake, a Mohawk community across the St. Lawrence River from Montreal, was present at a lacrosse game in Montreal for the visit of HRH Prince Arthur on October 9, 1869. Played for centuries by the Native groups of the St. Lawrence Valley, lacrosse became Canada's unofficial national game when rules were formalized in 1860. Photographed by James Inglis (1835–1904).

Opposite, top

The lacrosse team from Kahnawake was photographed in the Notman & Sandham studio in 1876. In those days, it was claimed that lacrosse "knock[ed] timidity and nervousness out of a young man, training him to temperance, confidence, and pluck."

Opposite, bottom

Wishe Ononsanorai, also known as Michael Deerhouse, a Mohawk lacrosse player from Kahnawake, 1876.

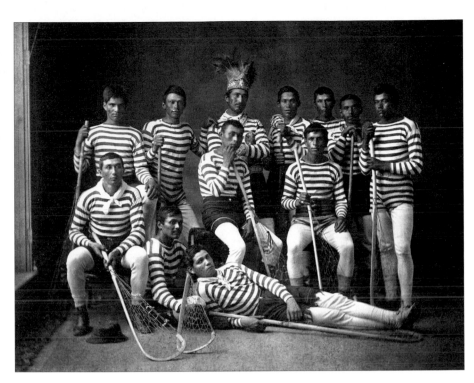

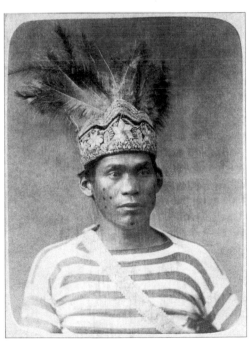

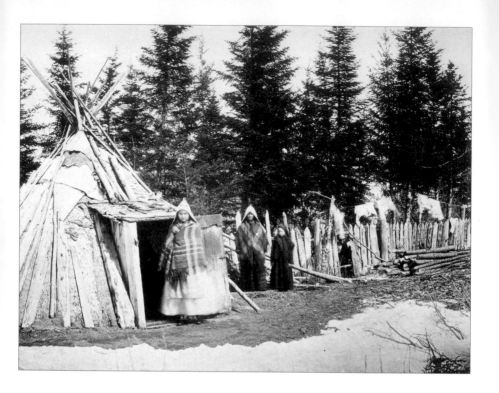

Above
This Cree camp was located near the Hudson's Bay
Company post at Rupert House, Quebec, *circa* 1865–1868.
Photographer Bernard Rogan Ross (1827–1874) led a group of
five HBC employees in learning the intricacies of wet-plate
(collodion) photographic processes at Moose Factory, on the
shores of James Bay, in the 1860s. They had to be the most
remote amateur photography group in the the world. Their
exceptional images recorded an inaccessible and virtually
unknown land.

Opposite, above
"Shooting the white bear." These men had fun reliving
the hunt for the camera of Bernard Rogan Ross at Rupert's
River, Quebec, *circa* 1865–1868.

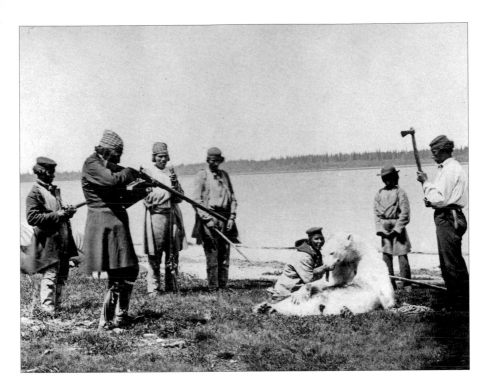

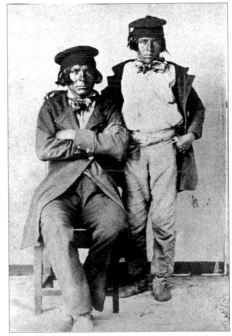

Right

Northern Cree man Red Stocking and his son, Chemallawais. This photograph was probably taken near Rupert House, Quebec, *circa* 1865, most likely by Bernard Rogan Ross. Cree territory stretched from the Atlantic Coast to the foothills of the Rocky Mountains. The original photograph was a *carte de visite*, an extremely popular type of small photograph (9 cm × 6 cm) mounted on a card that was easy to produce, send or store in Victorian photo albums.

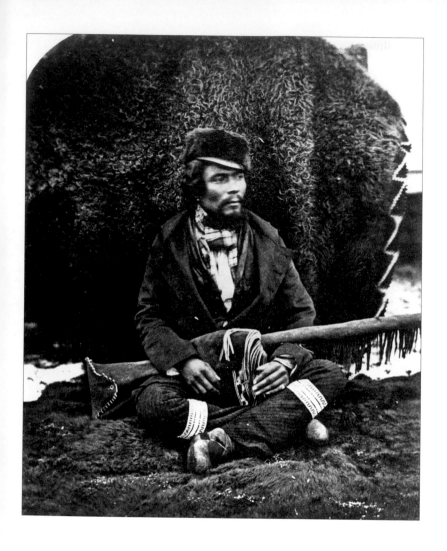

Wigwam, a Chippewa (Ojibwa) Métis, was photographed
at Lake Superior, 1857–1858, by Humphrey Lloyd Hime
(1833–1903). The Métis (the progeny of European traders and
First Nations women) became nations unto themselves. The
mainstay of the fur-industry workforce, they were a key factor
in the settlement of the West.

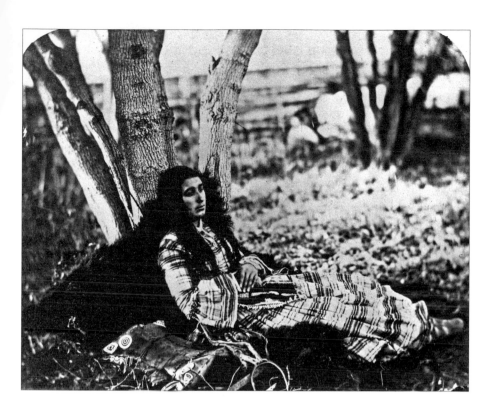

Letitia Bird, a Cree Métis woman from the Red River
Settlement in Manitoba, leans against a tree in fall 1858.
She was photographed by Humphrey Lloyd Hime during
the Canadian government-sponsored Assiniboine and
Saskatchewan Exploring Expedition. Using the bulky and
slow wet-plate (collodion) process, Hime made the first
photographs of the Canadian plains.

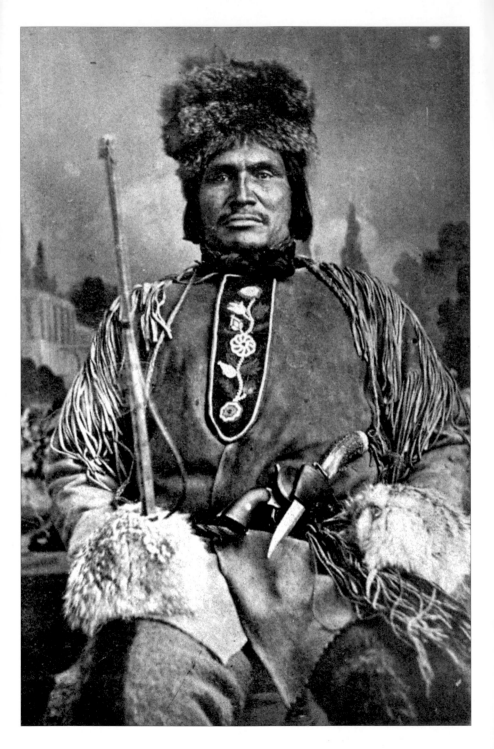

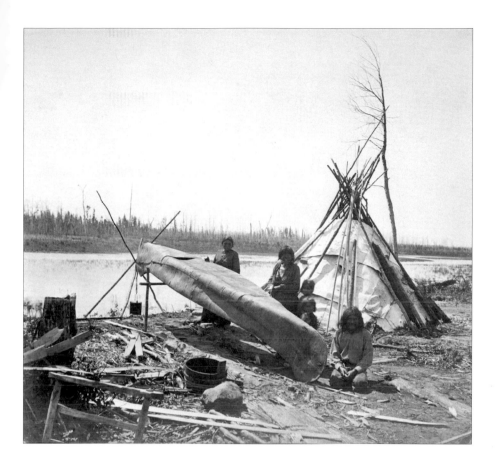

Opposite
Métis shaman Pa-pa-nay (George) Racette, a bit player in
the 1869 Red River Rebellion, photographed in Manitoba,
circa 1870, by an unknown photographer. This photo was
featured as an engraving in the May 16, 1884, edition of *The
Graphic*, and was labelled "Red River Insurgent."

Above
Building a birchbark canoe at an Anishinaabe (Chippewa,
also Ojibwa) camp, North West Angle, Lake of the Woods,
Ontario, October 1872. Photographed by the Royal Engineers
during the marking of the international boundary along the
49th parallel from this point to the Rocky Mountains.

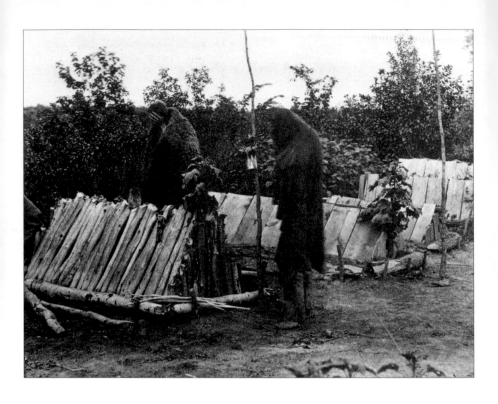

Mourners visit graves near Dufferin, Manitoba, *circa* 1873.
Dufferin was the winter headquarters of the Royal Engineers
and the British North American Boundary Commission.

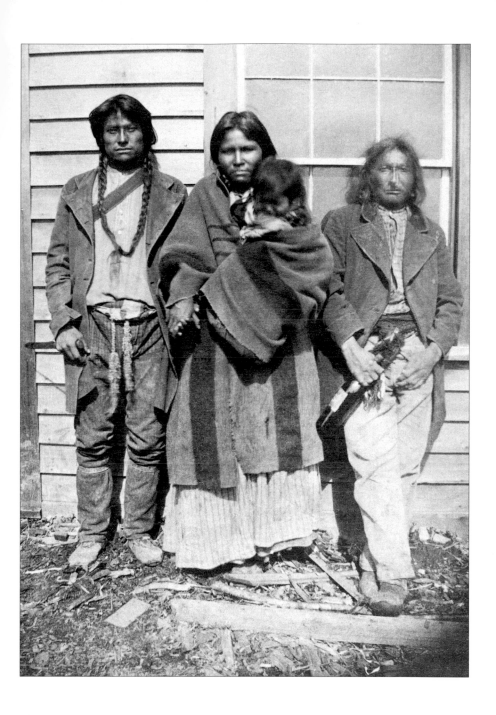

Chippewa (Ojibwa) Métis photographed by the Royal
Engineers at Dufferin, Manitoba, 1873–1874.

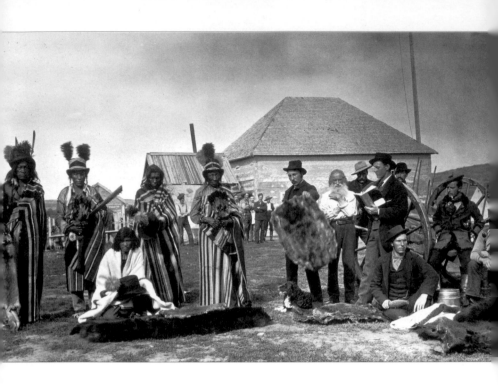

Plains Cree chief Mistahimaskwa (at centre, in vertical stripes), also known as Big Bear, was photographed by Oliver B. Buell (1844–1910) trading at Fort Pitt, Saskatchewan, in 1884. The following year, during the Northwest Rebellion, Big Bear's band took part in the Frog Lake Massacre, killing nine people and pillaging and burning Fort Pitt. Although he had not participated in the fighting—in fact he had saved the 44 residents of Fort Pitt—Big Bear was tried for treason and sentenced to three years in jail. He died in 1888 soon after his release. Photographed with him, from left to right: Fire Sky Thunder, Sky Bird (Big Bear's son), Matoose (seated), Napasis, Angus McKay (holding the fur) and other HBC employees.

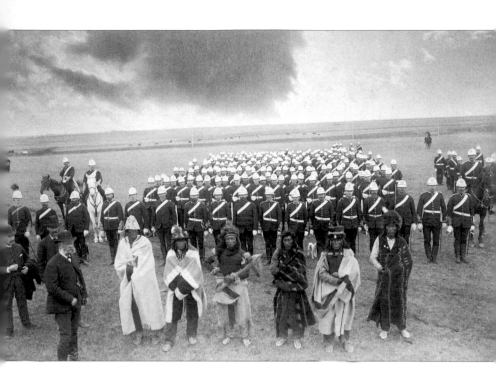

Above

Cree chief Piapot (second from left) with other chiefs and the Montreal Garrison Artillery near Regina, Saskatchewan, after the 1885 Northwest Rebellion, photographed by Oliver B. Buell. A skilled negotiator, Piapot did not participate in the rebellion, preferring to improve his people's lot through treaty negotiations—improvements that were vigorously thwarted by Lieutenant-Governor Edgar Dewdney (front with white sidewhiskers).

Pages 32–33

Mutsenamakan and his wife Mary One Spot, both Tsuu T'ina (Sarcee), were photographed near Calgary, Alberta, in 1887 by William Hanson Boorne (1859–1945). The Tsuu T'ina are part of the Blackfoot Confederacy, which includes the Siksika (Blackfoot), the Piikani (Piegan) and the Kainai (Blood).

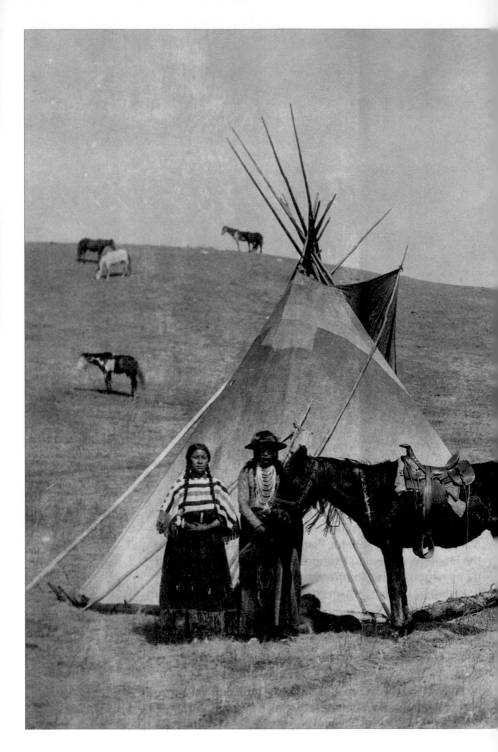

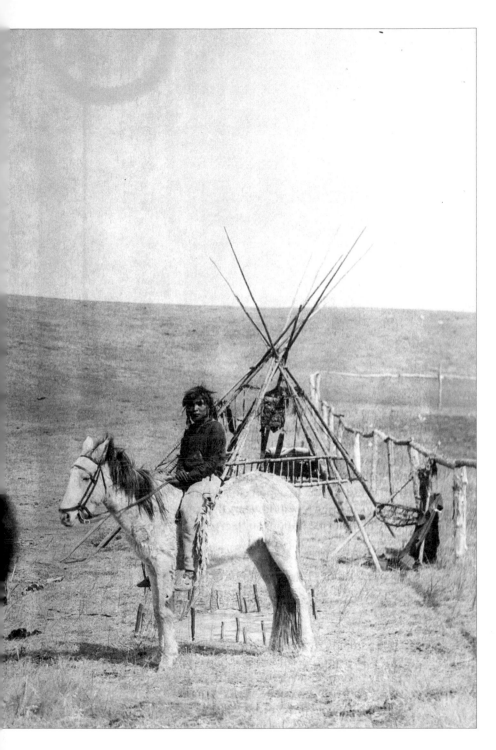

Opposite

Bull Head, a Tsuu T'ina (Sarcee) chief, was photographed by Alexander J. Ross (*circa* 1851–1894) in Calgary in 1887. Competitors in their industry, Ross and William Hanson Boorne were the most prolific and talented photographers in early Calgary. Aware that they were recording a significant transitional period in history, the two men created an amazing body of work in just a few short years that captured the forceful dignity of their First Nations subjects.

Page 36

This photograph by Alexander J. Ross might be of Running Deer, a Siksika (Blackfoot) man, *circa* 1885.

Page 37

Siksika (Blackfoot) champion runner Api-kai-ees (Bad-Dried-Meat), also known as Deerfoot, was photographed *circa* 1885, also by Ross. Calgary photographer Harry Pollard (1880–1968) later claimed the photographs—a common practice at the time—even though that would have meant Pollard was five years old when he took them.

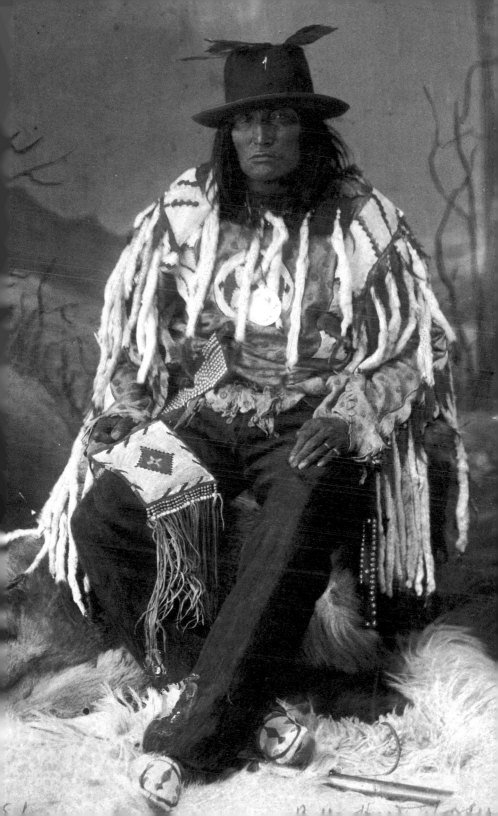

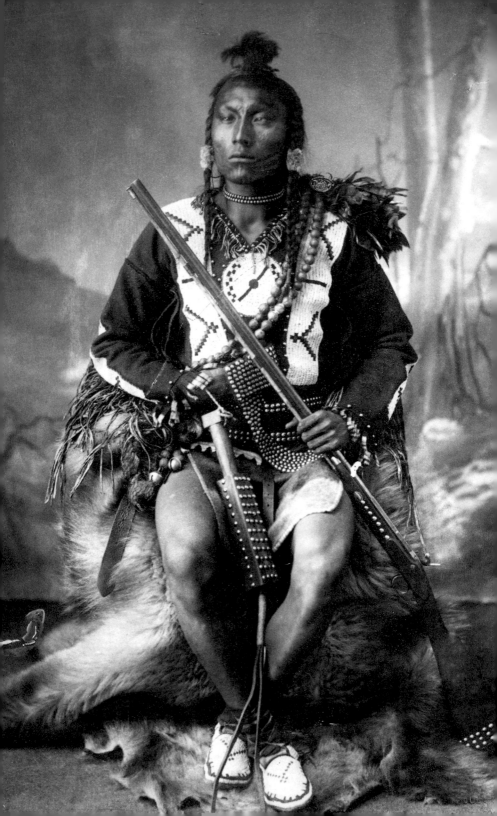

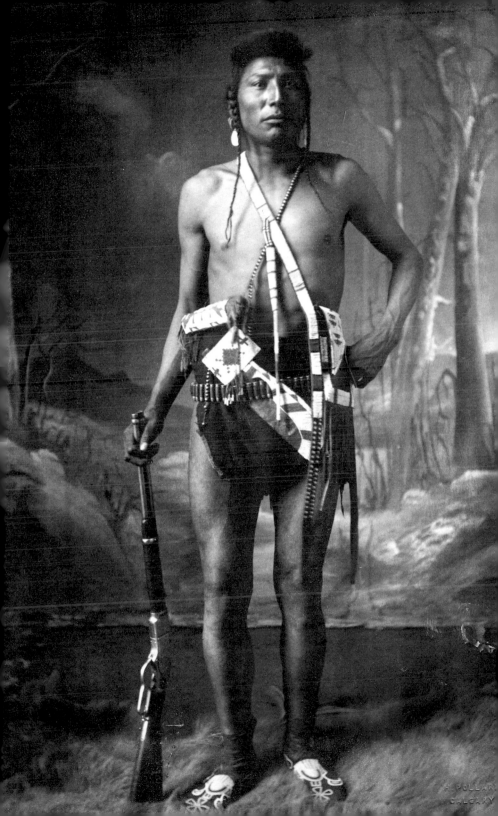

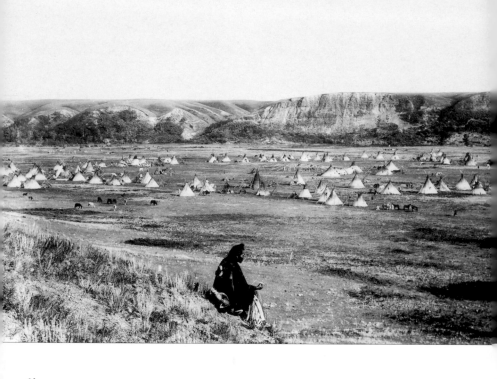

Above

The Great Sun Dance Camp was held at the Siksika (Blackfoot) Reserve near Gleichen, Alberta, *circa* 1893. It was photographed by Norman Caple (1866–1911).

Opposite

Mutsenamakan and Stumetsekini (Bull Caller), both Tsuu T'ina (Sarcee), were not very happy about being photographed in William Hanson Boorne's studio in Calgary, 1886. Boorne was one of the first to establish a photography studio in Calgary, which had barely existed before the arrival of the Canadian Pacific Railway in 1884. By the early 1880s, the wet-plate (collodion) process had been replaced by prepared dry-plate negatives (usually 20 cm × 25 cm). This greatly simplified the process: images could be exposed in the studio or out in the field, then developed later in a proper darkroom. Exposure times, especially in the studio, remained slow (half a second or more), resulting in a stiff and formal look.

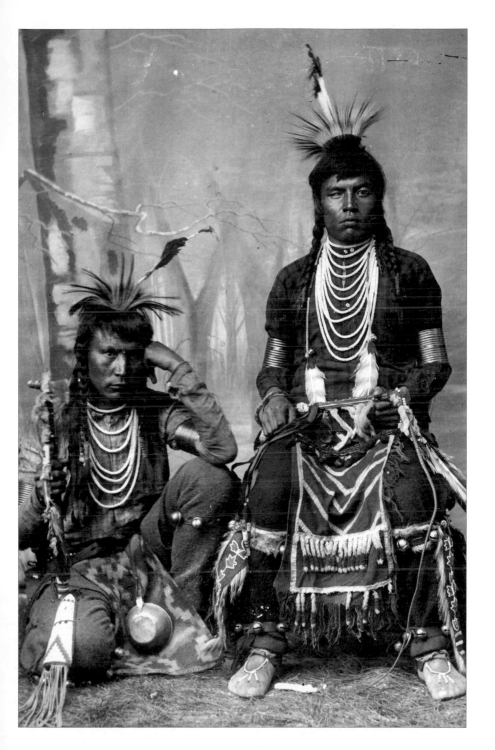

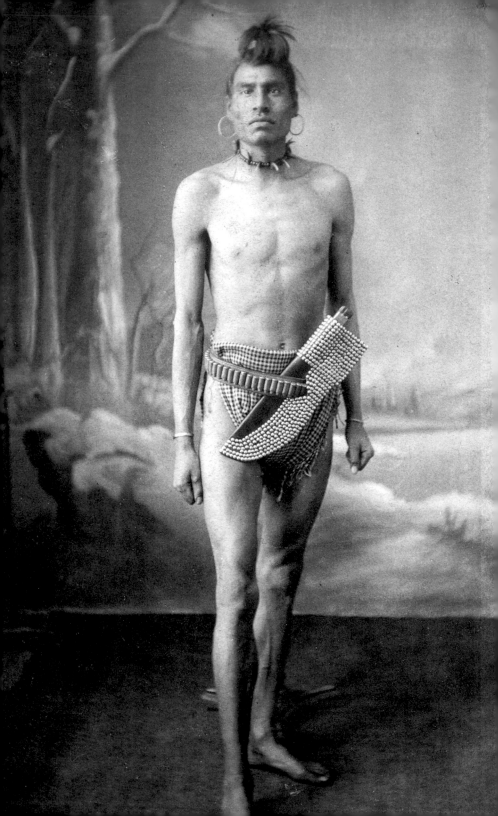

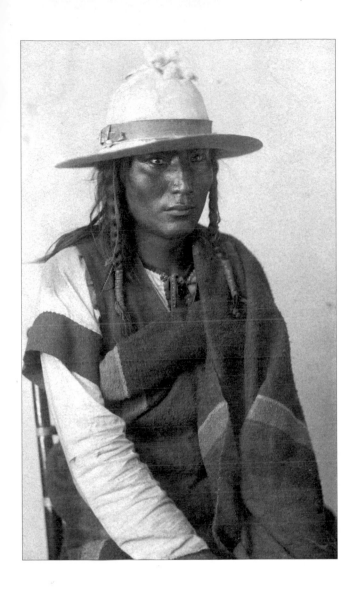

Opposite
Unidentified Siksika (Blackfoot) man, *circa* 1885,
photographed by Alexander J. Ross.

Above
Inashto-otan, Tsuu T'ina (Sarcee), in Calgary, Alberta,
circa 1887. Photographed by William Hanson Boorne.

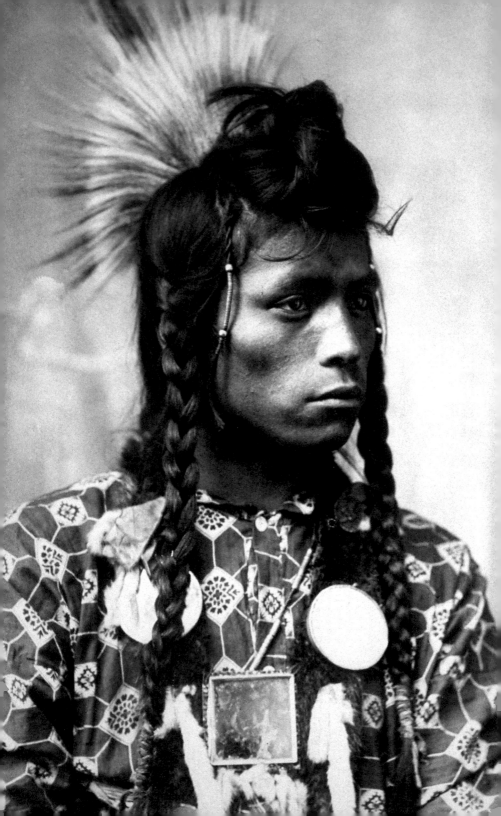

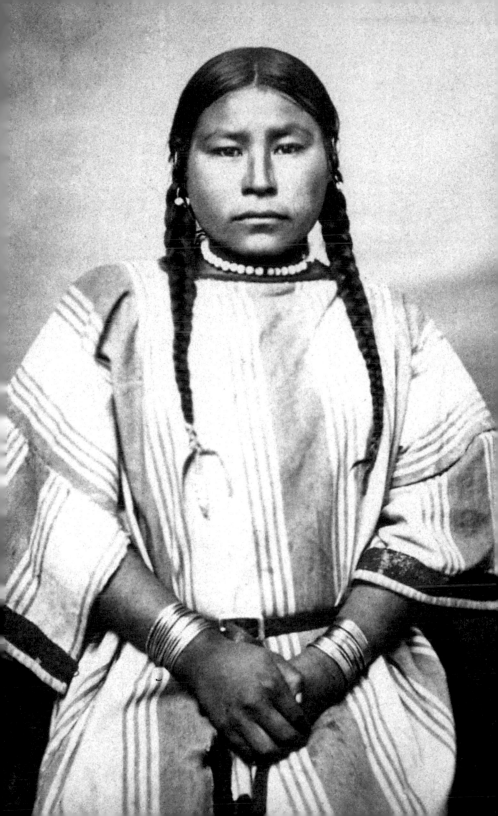

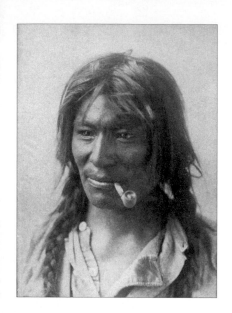

Page 42

Setukkomuccon (Jim Big Plume), Tsuu T'ina (Sarcee), was photographed in Calgary, Alberta, *circa* 1886, by William Hanson Boorne.

Page 43

A Hunkpapa Lakota (Sioux) girl is photographed by George Anderton (1848–1913) at Fort Walsh, in the Cypress Hills, Saskatchewan, *circa* 1878–1879. Anderton, a North West Mounted Police officer, became the first professional photographer on the Canadian plains. Originally posted to Fort Walsh, he took photographs throughout southern Alberta and Saskatchewan from 1876 and on.

Above

Chippewa (Ojibwa) man photographed in Winnipeg, Manitoba, *circa* 1885, by John Ross.

Opposite

Kainai (Blood) boys, Fort Macleod, Alberta, *circa* 1880. Photographed by George Anderton.

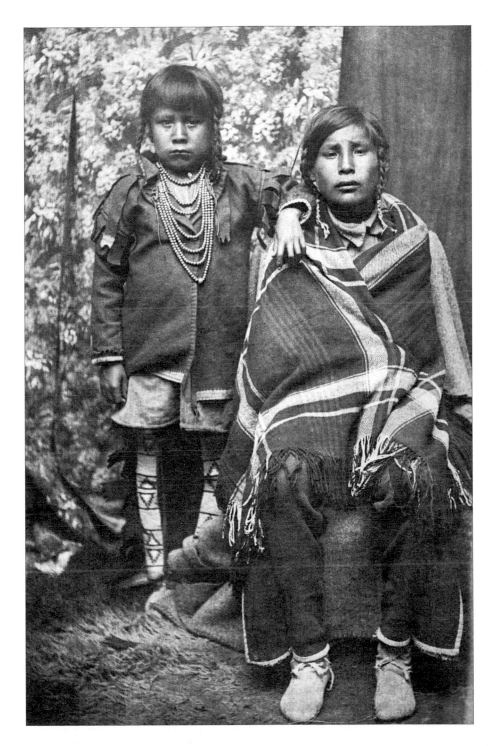

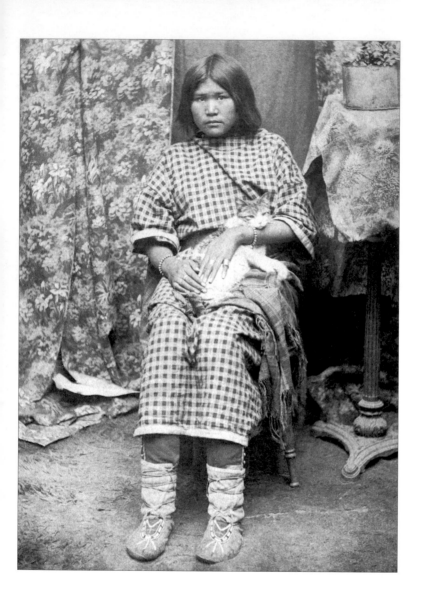

Siksika (Blackfoot) girl and a feline friend at Fort Macleod, Alberta, *circa* 1880. The origin and role of domestic cats on the western plains is somewhat vague, but Wesleyan missionary Robert Rundle did travel around southern Alberta in the 1840s with a pet black cat that reportedly amazed the indigenous residents and sorely vexed the poor reverend. Photographed by George Anderton.

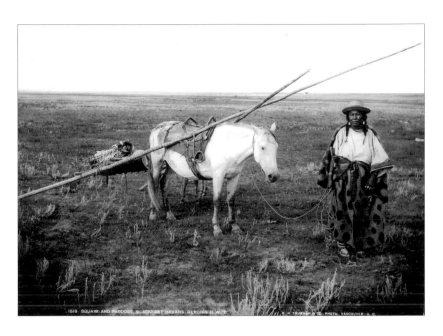

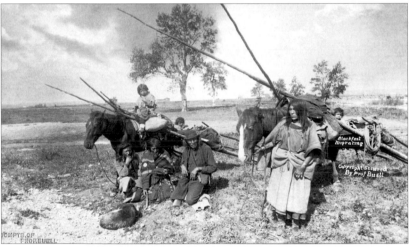

Above, top

Mrs. Tom Turned Up Nose, a Siksika (Blackfoot), stands with her horse and travois near Gleichen, Alberta, *circa* 1893, for a photograph by Norman Caple.

Above, bottom

Siksika (Blackfoot) family migrating, *circa* 1885, Oliver B. Buell.

Opposite

In 1886, Isapo-Muxika, also known as Crowfoot, the head chief of the Blackfoot Confederacy, was photographed in Calgary by Alexander J. Ross. A noted peacemaker, Crowfoot, who was Kainai (Blood), came to lead the Blackfoot Confederacy in 1870. By making peace with the Cree (traditional enemies of the Blackfoot), welcoming the North West Mounted Police in 1873 and signing Treaty Seven in 1877, Crowfoot was a major influence in the peaceful settlement of western Canada. The framed item slung over his shoulder is his honorary Canadian Pacific Railway pass.

Page 50

Sixapo, also known as Black Plume, was Kainai (Blood). This photograph was taken in 1895. It may have been taken by Frederick Steele (1860–1930) in his studio in Winnipeg, but not necessarily, as the photographer travelled extensively throughout western Canada.

Page 51

This photograph, also by Frederick Steele, features a Piikani (Piegan) named Acustie, also known as Many Diving, *circa* 1895. Piikani territory ranged throughout southern Alberta, Saskatchewan and Montana.

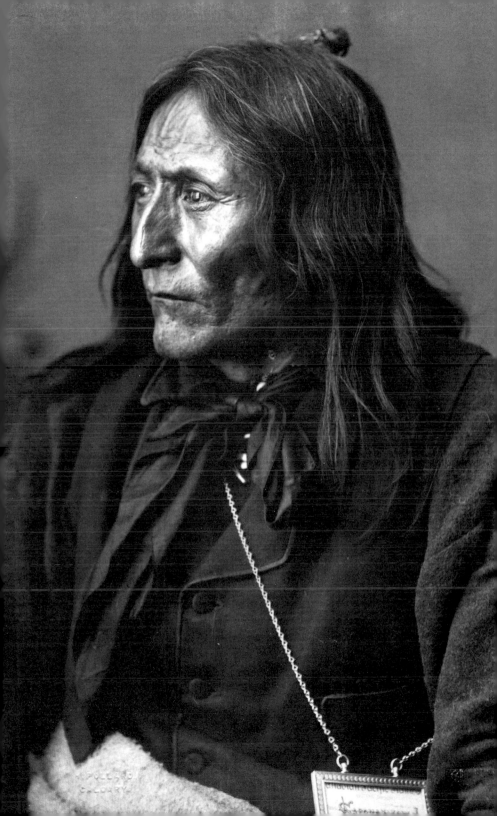

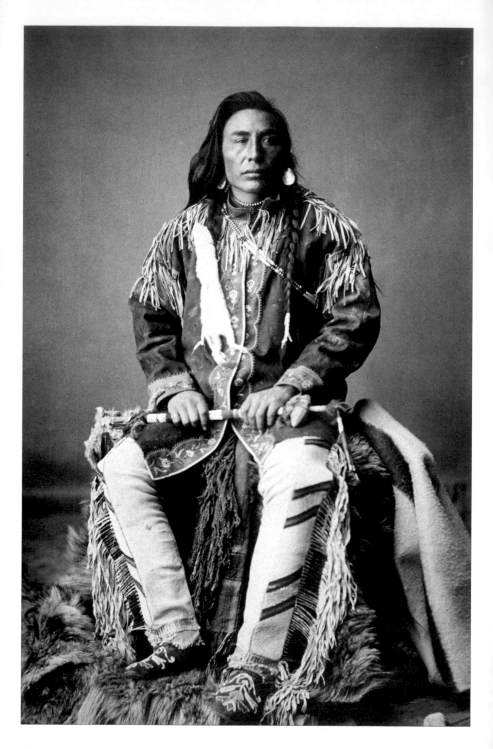

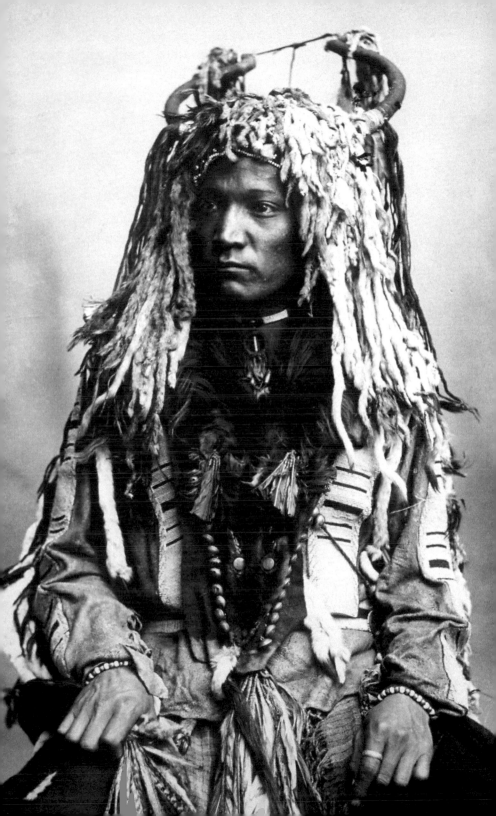

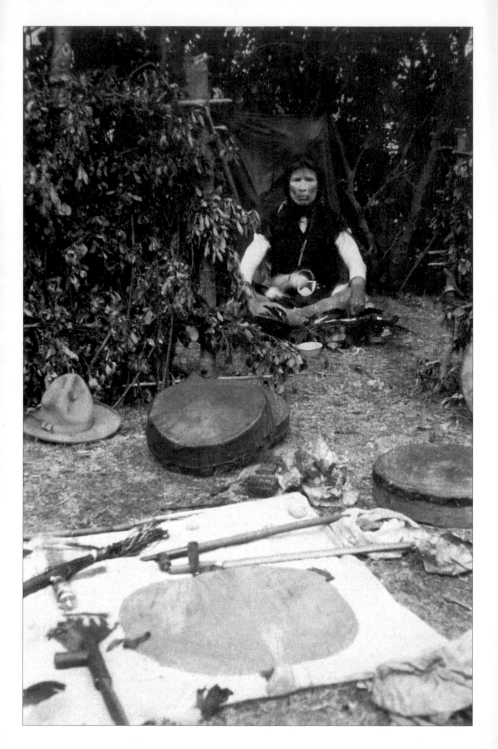

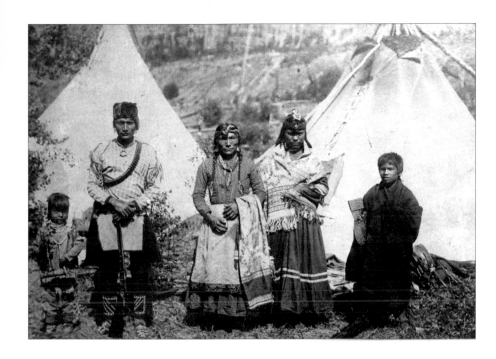

Opposite
Sitting Eagle (John Hunter), a Stoney Nakoda, prepares for a
Sun Dance, *circa* 1915. This photograph was taken by Byron
Harmon (1876–1942).

Above
Amos Big Stoney and his family (Stoney Nakoda) are camped
near Cascade Mountain in Banff National Park, Alberta, 1889.
The photograph was taken by Adam B. Thom (1849–1926).

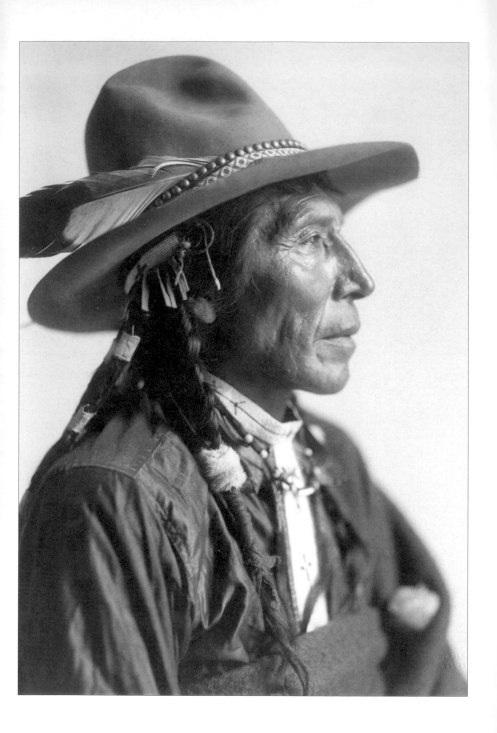

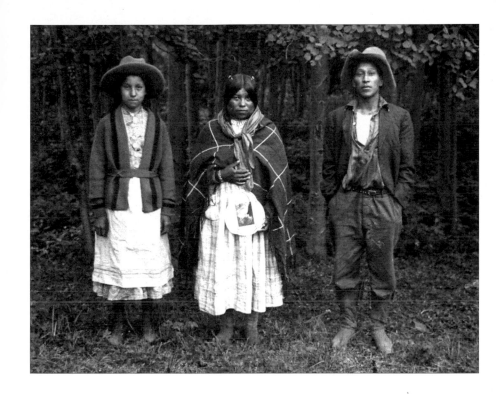

Opposite
Many Shot, Siksika (Blackfoot), *circa* 1910. Photographed by Harry Pollard.

Above
A Stoney Nakoda group photographed by Byron Harmon during the Banff Indian Days, *circa* 1920. The annual summer celebration was held in Banff National Park from 1900 through 1978. Changing attitudes about First Nations peoples being presented as "sideshow performers" caused the event's demise. It was resurrected by the Stoney Nakoda in 1992. The picture on the fan held by the woman in the centre is of film star Mary Pickford.

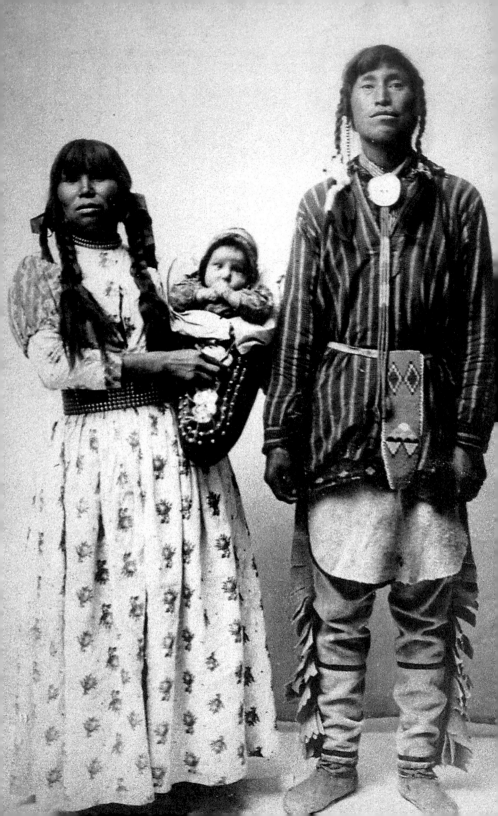

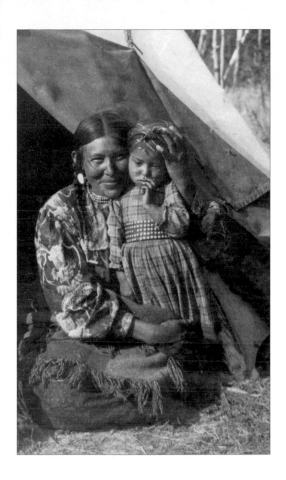

Opposite

Morley Beaver and his family (Stoney Nakoda) pose for Byron Harmon, *circa* 1910.

Above

Stoney Nakoda mother and child, Kootenay Plains, Alberta, 1907. Photographed by Elliott Barnes (1866–1938).

Pages 58–59

Sampson and Leah Beaver pose with their daughter, Frances Louise, on the Kootenay Plains in Alberta, 1907. Sampson Beaver drew a map to Chaba Imne (Beaver Lake) for the photographer Mary T. S. Schäffer (1861–1939), enabling her party to be the first Europeans to visit what would be called Maligne Lake, in Jasper National Park.

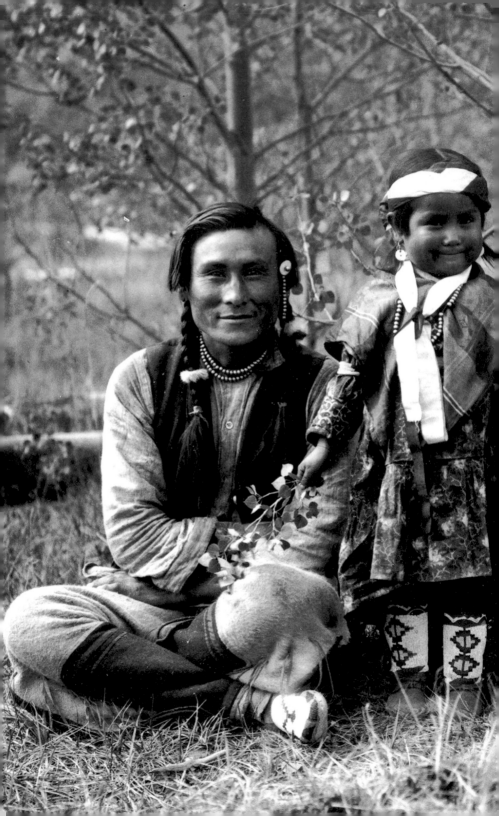

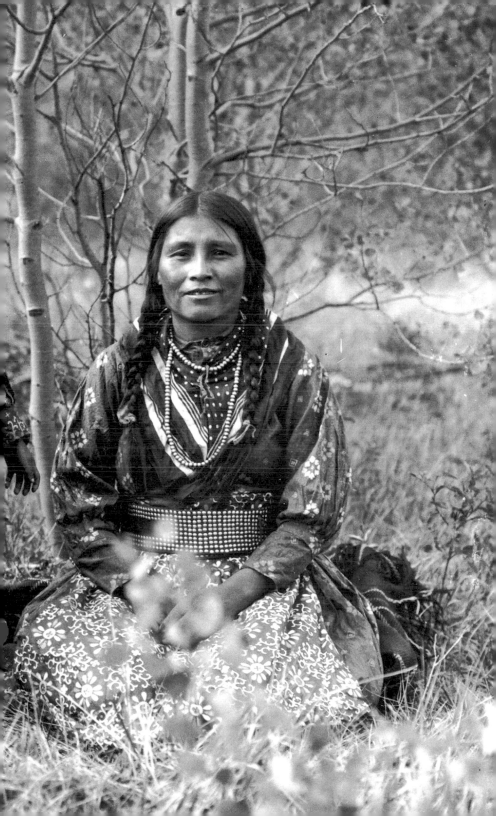

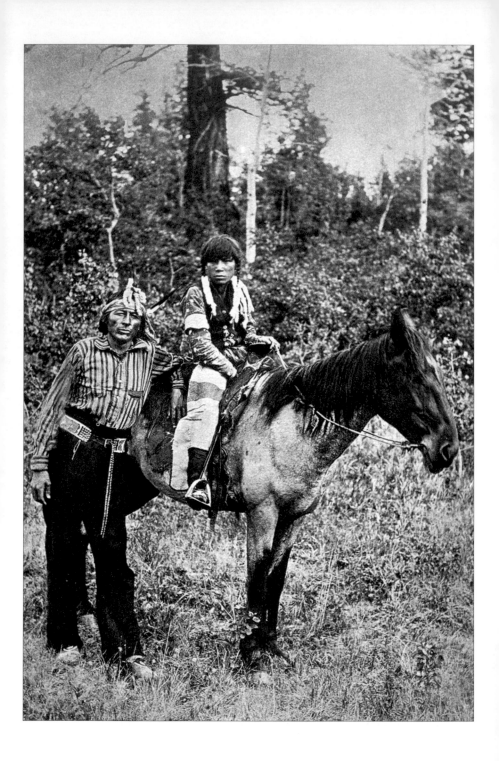

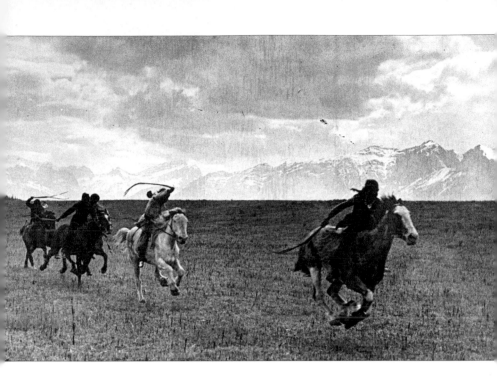

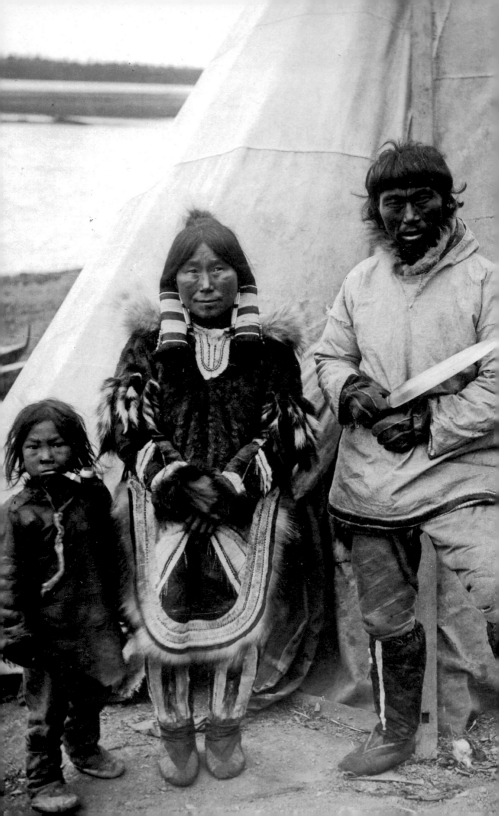

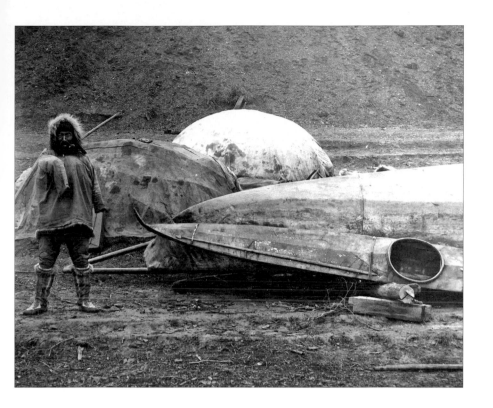

Opposite

An Inuvialuit family poses for Charles W. Mathers (1868–1950), Peel River, Northwest Territories, in 1901. Originally called Eskimos or Esquimaux by early Europeans, these terms are now considered derogatory because they mean either "flesh eaters" or "net snowshoes" in Ojibwa. The accepted names, "Inuit," meaning "people," for the Eastern Arctic or Nunavut people and "Inuvialuit," meaning "real people," for the Western Arctic people, are used today.

Above

This photograph, also taken by Charles W. Mathers, shows an Inuvialuit standing next to a topek (summer house) and kayak at Peel River, Northwest Territories, in 1901.

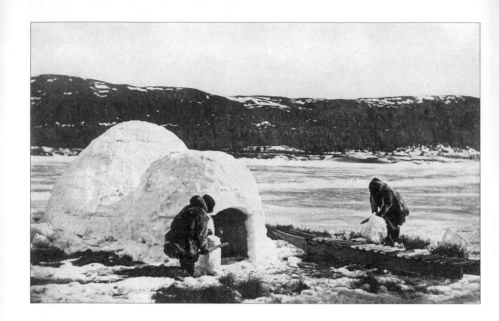

Above

Building an igloo, Little Whale River, Quebec, 1872. Igloo is the Inuit word for "house"; it can be made of any material. At this time Little Whale River was an active trading post and the district headquarters for the Hudson's Bay Company. The same group of dedicated amateur photographers from Moose Factory, including junior chief trader James Laurence Cotter (1839–1889) and the region's surgeon, Dr. William Bell Malloch (1845–1881), created a unique series of photographs depicting Arctic life.

Opposite, top

Interior of a snow house, Cape Fullerton, Hudson Bay, 1903–1904. The photographer of this image, Albert Peter Low (1861–1942), was with the Geological Survey of Canada.

Opposite, bottom

Albert Peter Low protographed this group inside an igloo at Cape Fullerton, Hudson Bay, in 1903–1904. The bearded man in the centre is She-nuck-shoo (also pictured on page 69). A favourite wintering spot for whalers, government officials, scientists and traders, Cape Fullerton was a virtual photographic beehive. No fewer than five other photographers produced images at this remote site around the same time.

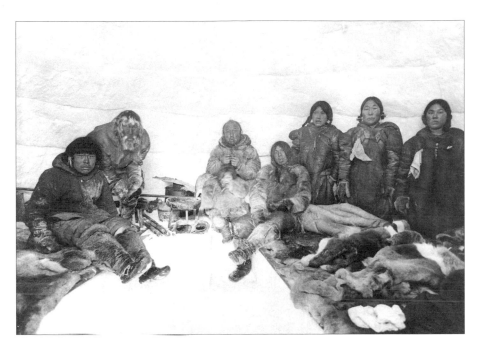

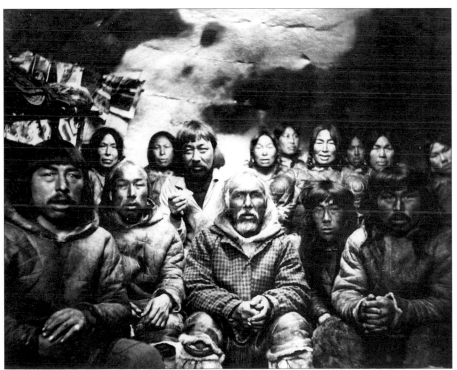

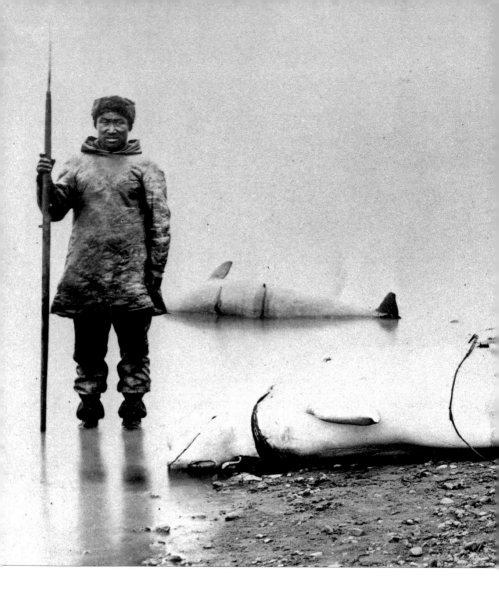

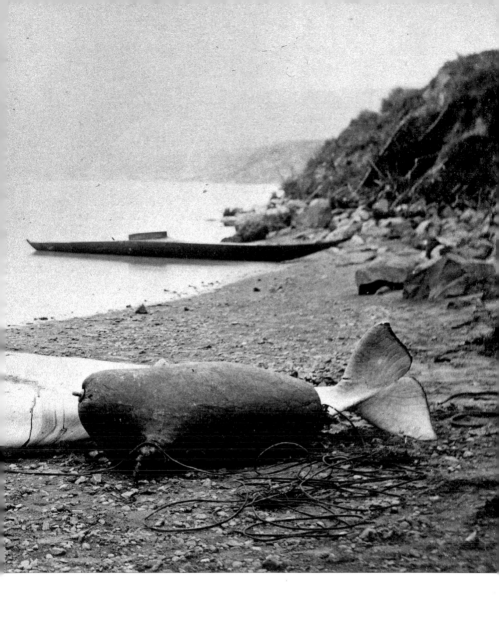

An Inuit hunter poses with beluga whales at Little Whale River, Quebec, *circa* 1865. Photographed by George Simpson McTavish (1834–18?).

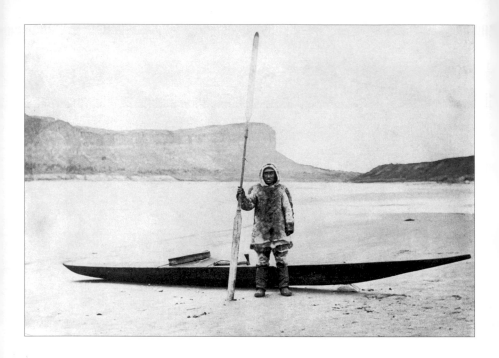

Above

Inuit and kayak, Little Whale River, Quebec, *circa* 1874,
photographed by Dr. William Bell Malloch (1845–1881).

Opposite

She-nuck-shoo, chief of the Aivilingmiut, which means
"people of the walrus," is photographed in Geraldine
Moodie's shipboard studio on the SS *Arctic* at Cape Fullerton,
near Chesterfield Inlet, on the northwest coast of Hudson Bay,
Nunavut, 1904–1905. Moodie (1854–1945) was a professional
photographer and the wife of Royal North West Mounted
Police superintendent J. D. Moodie. She accompanied her
husband on his northern tour from 1904 to 1907 to establish a
post at Cape Fullerton on Hudson Bay.

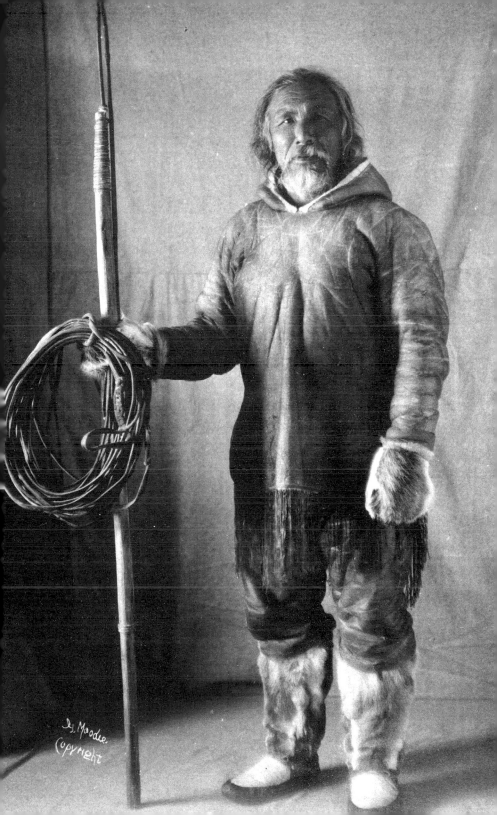

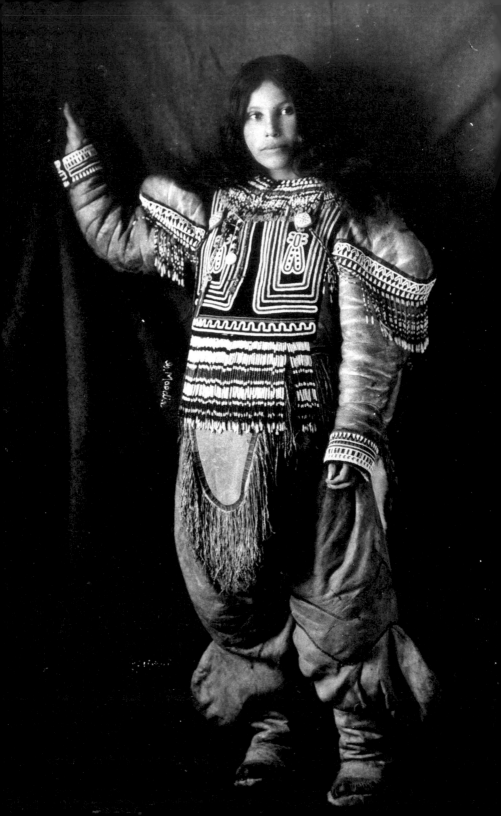

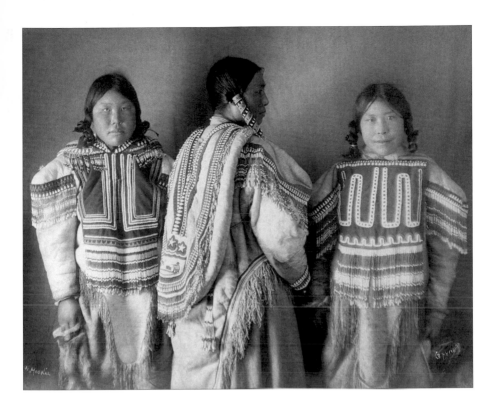

Koo-tuck-tuck, an Inuit, is photographed at Cape Fullerton, Hudson Bay, 1904–1905. Photographer Geraldine Moodie had noted that the subject was a "deaf mute."

Tu-uck-lucklock, Neveshenuck, Towtook, Inuit women at Cape Fullerton, 1905. Photographed by Geraldine Moodie.

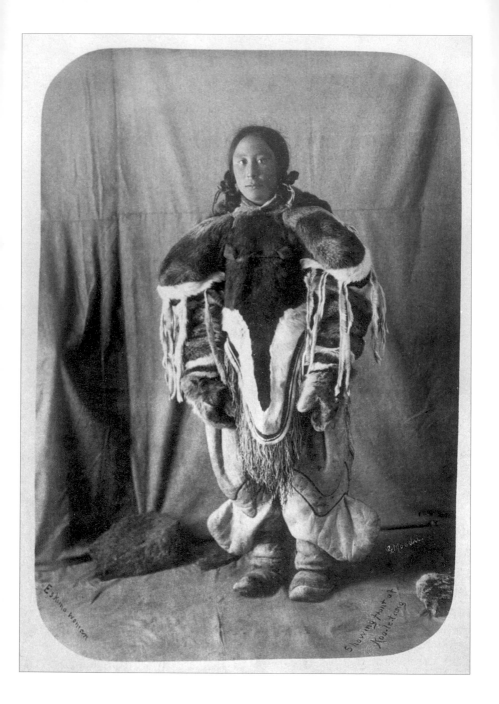

Ungunga, an Inuit woman, at Cape Fullerton, 1905.
Photographed by Geraldine Moodie.

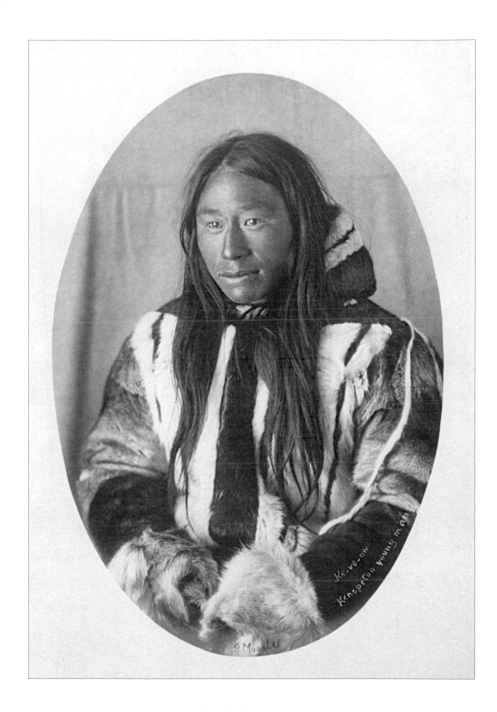

Keveowk, a Kenepetoo man at Cape Fullerton, 1905.
Photographed by Geraldine Moodie.

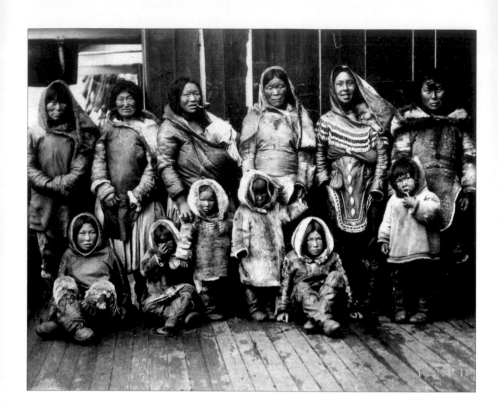

A group of Inuit women and children aboard the SS *Arctic*, at Erik Cove, Ungava, Quebec, photographed by Geraldine Moodie in 1904.

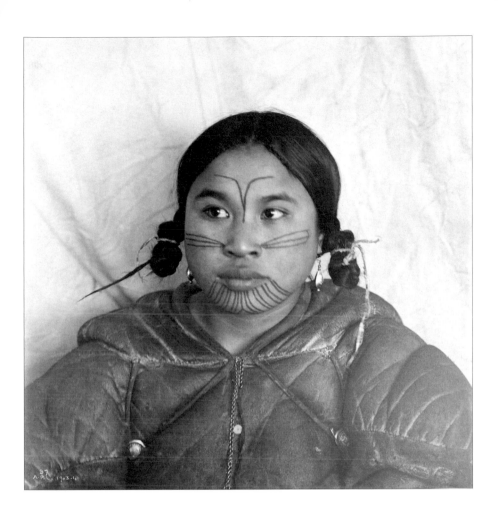

"Baffinland Woman" at Cape Fullerton, 1903–1904.
Photographed by Albert Peter Low. Facial tattooing was
a common practice for Inuit women across the North
American Arctic. This very traditional pattern, representing
maturity, status and spiritual considerations, was sewn
through the skin using sooted sinew.

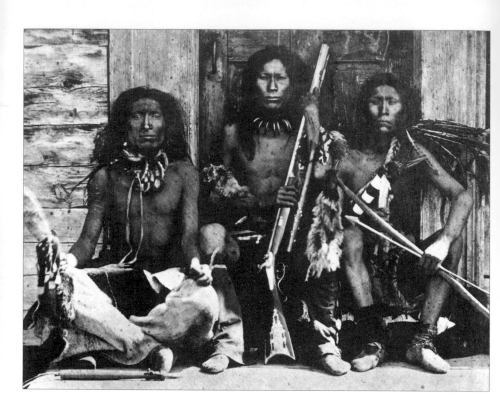

These unidentified Colville or Spokane members (Salish)
were photographed by the Royal Engineers at the Hudson's
Bay Company's Fort Colville, in Washington, 1860–1861,
during the marking of the international boundary.

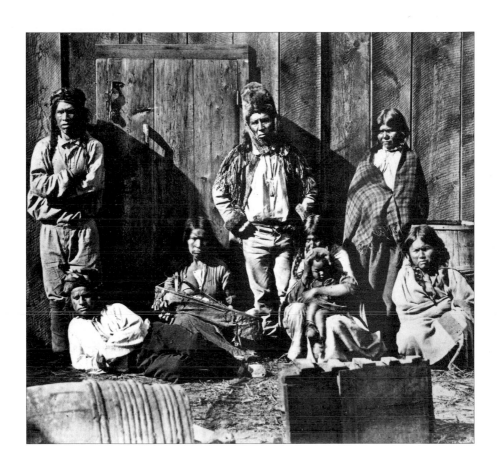

This group was photographed by Frederick Dally (1838–1914) at Lytton, on the Fraser River in British Columbia, *circa* 1867. Siseanjute, chief of the Bonaparte (part of the Shuswap Nation), is standing against the wall on the left. Dally arrived in Victoria, British Columbia, at the height of the Cariboo gold rush in 1862, and was originally a merchant. He begain working as a photographer in 1866.

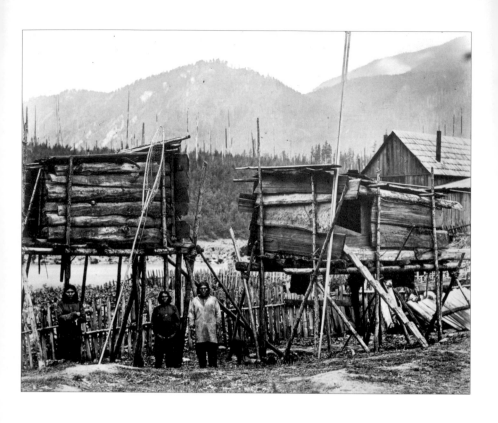

Stó:lō (also called Coast Salish) salmon caches line the Fraser
River near Yale, British Columbia. Nets on long poles for use
in the river's rapids and two long salmon spears can be seen.
This photograph was taken by Frederick Dally in 1867–1868.

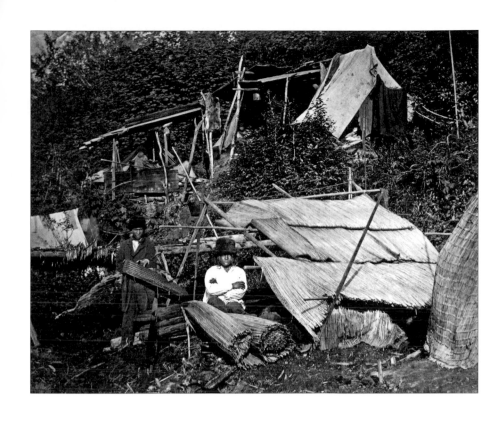

This photograph by Frederick Dally shows a Stó:lō (Coast Salish) encampment near New Westminster on the Fraser River, British Columbia, *circa* 1867–1868.

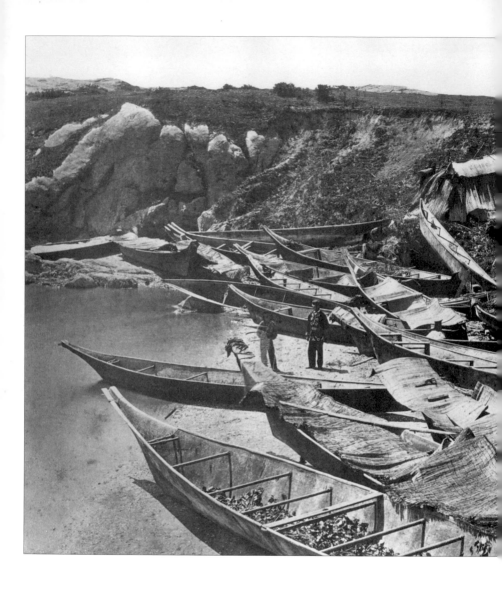

Chinook-style canoes on the Songhees Reserve in Victoria, British Columbia, 1869. The photographer, Frederick Dally, noted that the canoes belonged "to the invited visitors to the great potlatch." This traditional gifting celebration, practised throughout the Northwest Coast, was banned by the Canadian government in 1885.

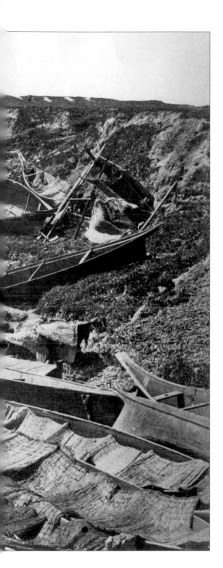

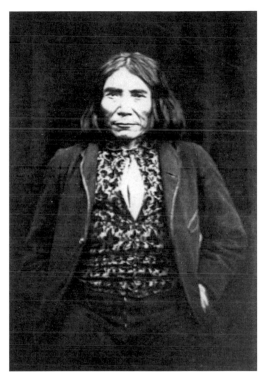

Above, right
James Sqwameyuks, Songhees chief *circa* 1797–1892, Victoria,
British Columbia, 1866–1868. Photographed by Frederick Dally.

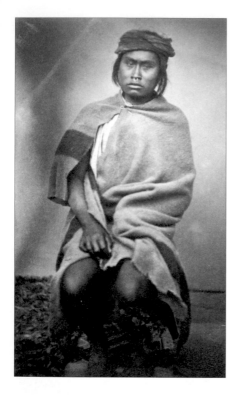
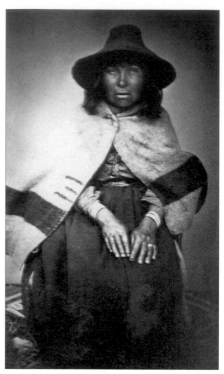
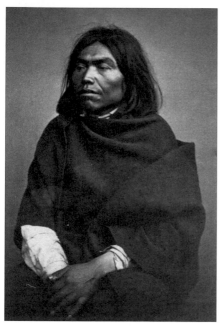
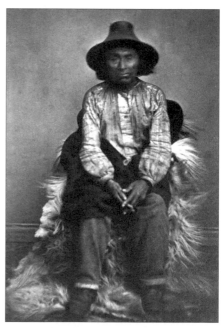

82

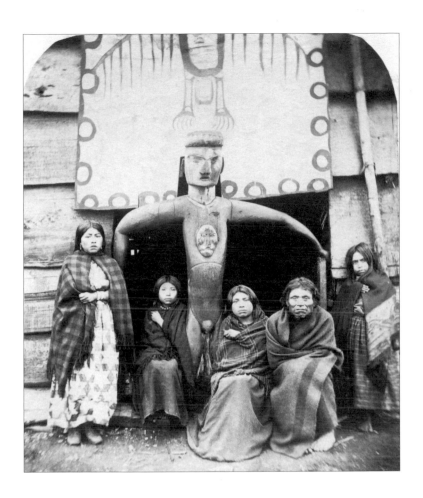

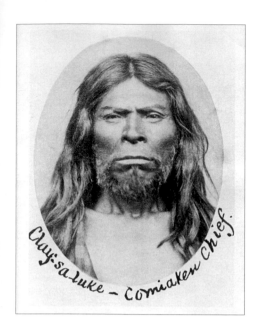

Above

Clay:sa-luke, a Comiaken (one of the seven nations of the Cowichan group) chief, Vancouver Island, 1867–1869. Photographed by Frederick Dally.

Opposite, top

Snuneymuxw First Nations group on the dock at Nanaimo, Vancouver Island, 1867–1869, captured by an unknown photographer. The older man in the centre is Che-wech-i-kan, the "Coal Tyee" who, in 1850, was the first to inform the Hudson's Bay Company of the "rocks that burn" in Nanaimo. This discovery led to the creation of the Pacific coast's major coaling stations for both the Hudson's Bay Company and the British navy.

Opposite, bottom

A Cowichan family is photographed on Vancouver Island, British Columbia, in 1867–1869. Small stereo images like this one were mass entertainment in the 19th century. The two photographs, viewed in a hand-held stereoscope, fused into a glorious three-dimensional image. Produced in the millions, the inexpensive stereo photographs brought the cultures and landscapes of the entire world into 19th-century homes.

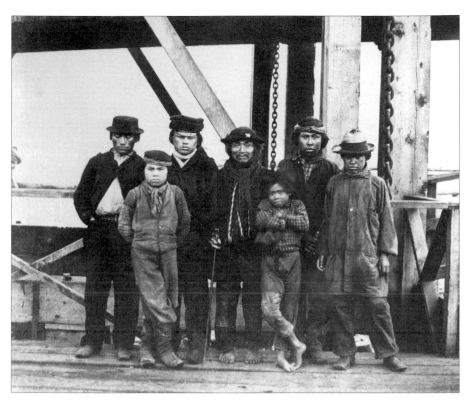

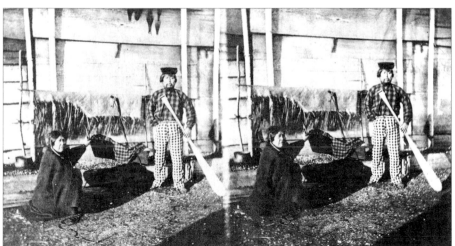

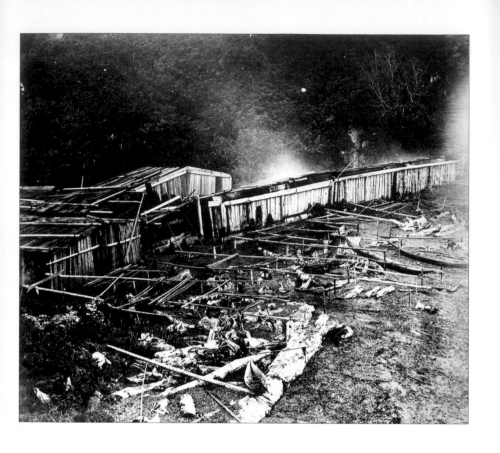

These cedar-plank houses in Quatsino Village, Quatsino Sound, were on the northwest coast of Vancouver Island, British Columbia. This photograph was taken in 1866 by Frederick Dally.

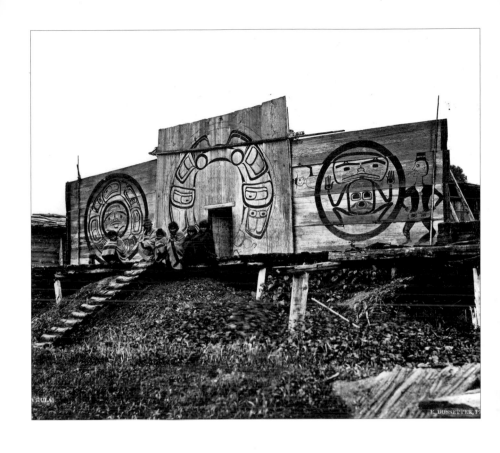

This cedar-plank house at Bella Coola (Nuxalk Nation, Kwagiutl), British Columbia, was photographed in 1881 by Edward Dossetter (active 1881–1890). A century earlier, in July 1793, the Nuxalk Nation forcibly turned Alexander Mackenzie back just as he reached salt water at Bella Coola, becoming the first European to cross the North American continent. Earlier dealings with European traders who came by sea had soured the Nuxalk's opinion of the new arrivals. During the 19th century, up to 80 percent of the coast's inhabitants died of diseases brought by Europeans.

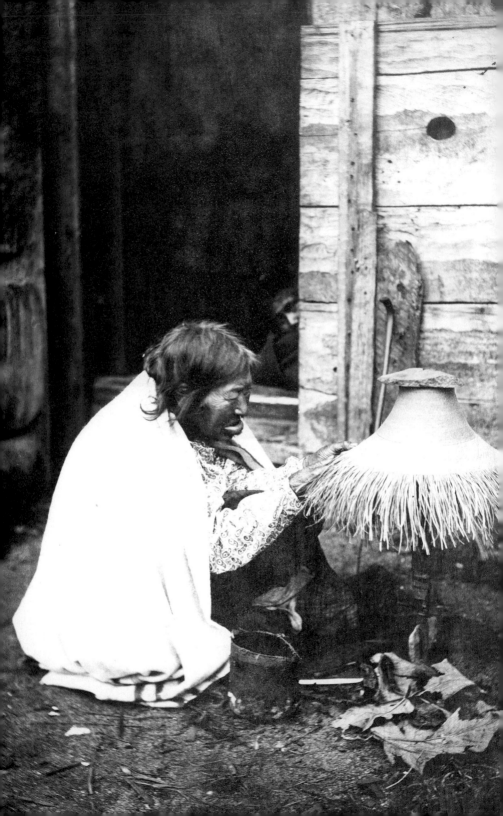

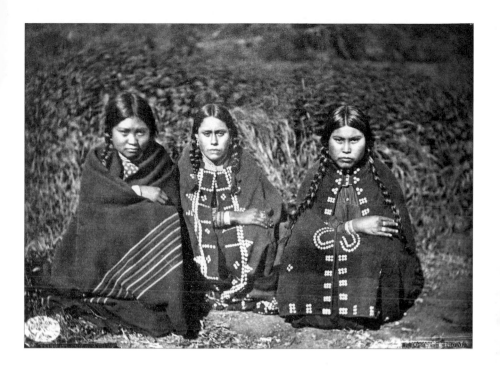

Opposite

A Haida woman weaves a traditional spruce-root hat in Yan, Haida Gwaii (Queen Charlotte Islands), British Columbia, 1881, photographed by Edward Dossetter while he accompanied Indian Affairs Commissioner Dr. Israel Wood Powell on an inspection tour of the British Columbia coast in 1881. Powell replaced his predecessor, Gilbert M. Sproat, after accusing him of being "too generous with land allotments."

Above

Kwakwaka'wakw girls, Kwa Swelth Tribe, Tsaunati, Knight Inlet, British Columbia, 1881, also by Edward Dossetter.

Pages 90–91

A group of Haida is photographed in Yan, Haida Gwaii (Queen Charlotte Islands), British Columbia, in 1881. The pole in the foreground commemorates Eagle chief Ildjiwes. Yan means "Beeline Town"; the 17 homes are arranged in a straight line. Established in the late 18th century, the village was abandoned shortly after Dossetter took this photo. The residents moved to nearby Masset.

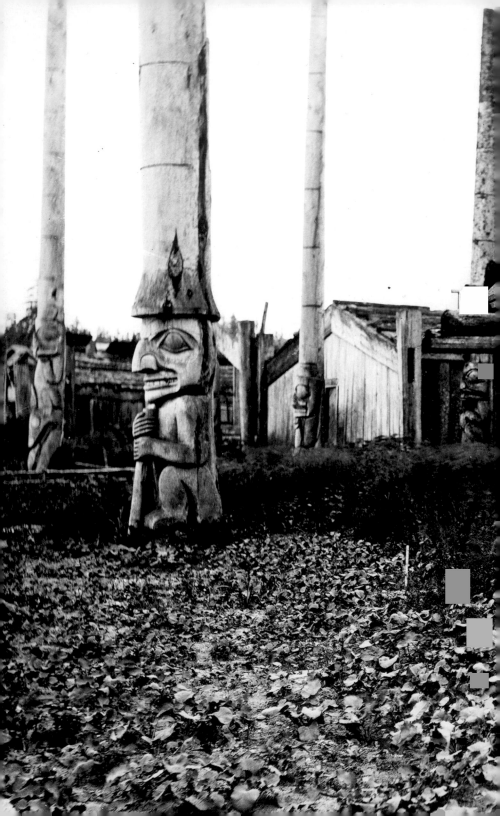

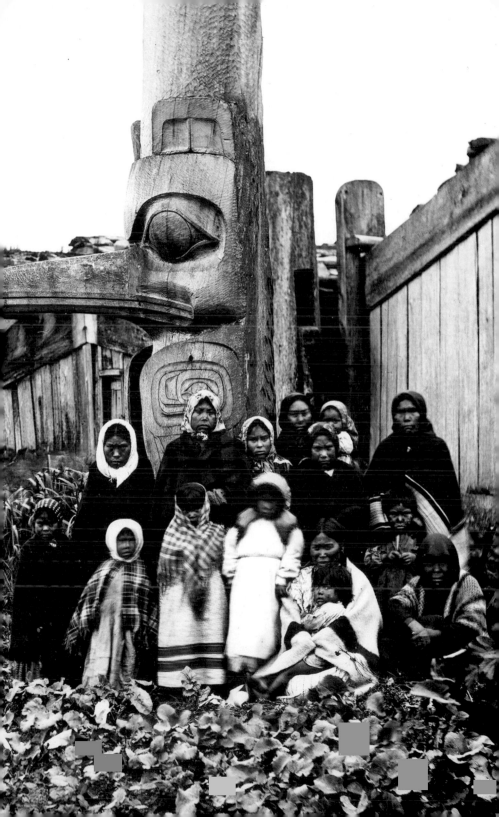

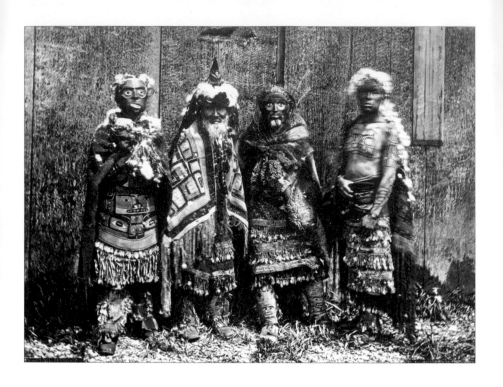

The subjects of this photograph by Edward Dossetter include
noted Haida shaman and chief Dr. Kudé (second from left),
Xa'na (far right), and other shamans of Masset, Haida Gwaii
(Queen Charlotte Islands), British Columbia, in 1881. This is
the only known photograph of 19th-century Haida shamans
wearing masks. The two at right are wearing shaman's
aprons, while Dr. Kudé is wearing a chief's Chilkat blanket.

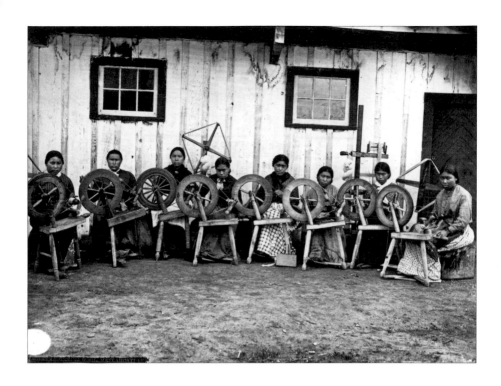

Women at Metlakatla, British Columbia, 1881. Photographed by Edward Dossetter. Anglican lay minister William Duncan established this utopian Christian community with Tsimshians from Lax Kw'alaams (Port Simpson).

Pages 94–95

Graves at Salmon River, Comox area of Vancouver Island, British Columbia, 1881. Photographed by Edward Dossetter.

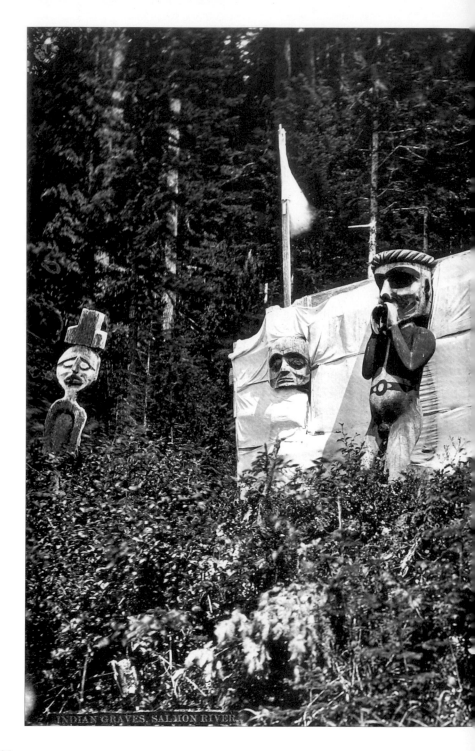

INDIAN GRAVES, SALMON RIVER.

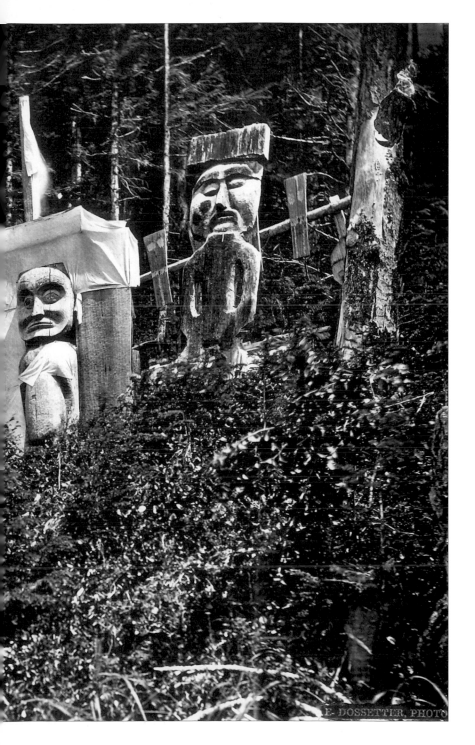

E. DOSSETTER, PHOTO

About the Author

Edward Cavell has worked with historical photography in Canada for more than 30 years. Former curator at the Whyte Museum of the Canadian Rockies in Banff, Alberta, and author of seven illustrated histories, Cavell has pored through hundreds of thousands of photographs in archives, museums, and private collections across Canada and abroad. This book is drawn from the author's extensive and eclectic collection of reference prints from numerous collections, ranging from Library and Archives Canada to the British Museum in England. His published works include *Sometimes a Great Nation, Journeys to the Far West,* and *Rocky Mountain Madness.*

Photo Credits